STEAMPUNK ANIMALS
COLORING BOOK

JEREMY ELDER

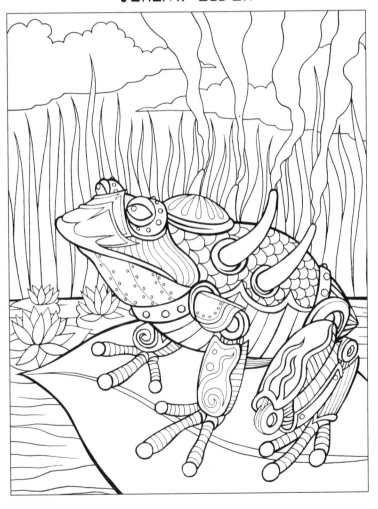

DOVER PUBLICATIONS, INC.
MINEOLA, NEW YORK

This parade of fantastic animals wearing steampunk regalia will take your imagination on a journey of creativity and fantasy. Join the explorations of these Victorian, yet futuristic, animals—some as small and simple as a snail, bird, or bunny rabbit, and others as large as a horse, tiger, or elephant—all wearing unusual mechanical inventions or automata, and many spewing smoke from their armor. Enjoy coloring this menagerie of thirty steampunk animals with media of your choice!

Bibliographical Note
Steampunk Animals Coloring Book is a new work,
first published by Dover Publications, Inc., in 2016.

International Standard Book Number
ISBN-13: 978-0-486-79904-9
ISBN-10: 0-486-79904-2

Manufactured in the United States by RR Donnelley
79904201 2016
www.doverpublications.com

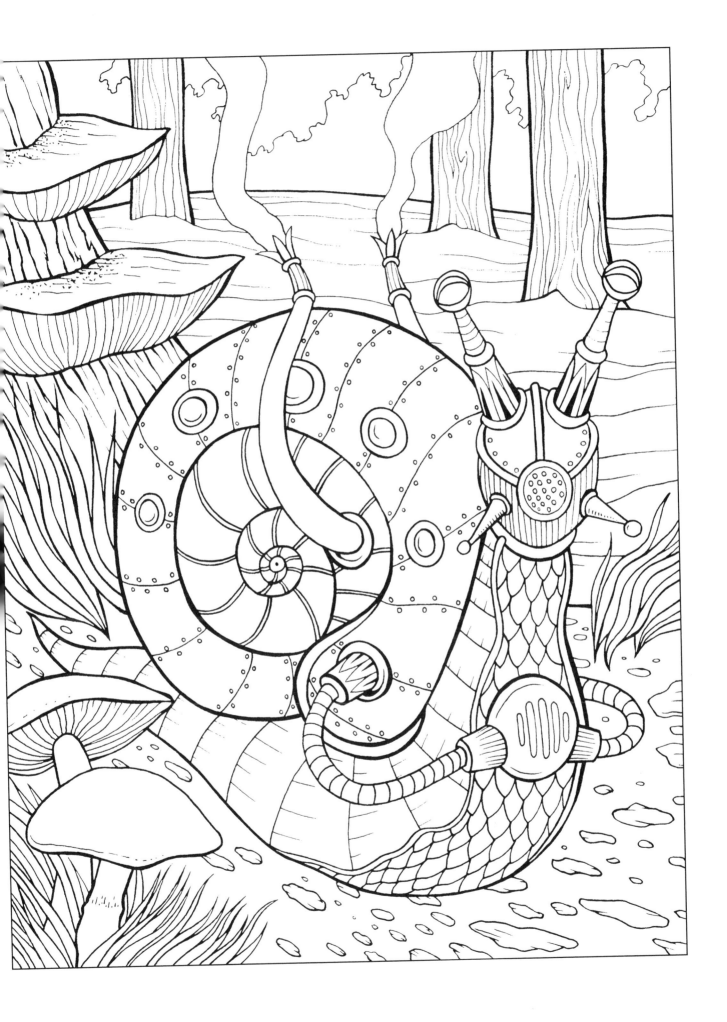

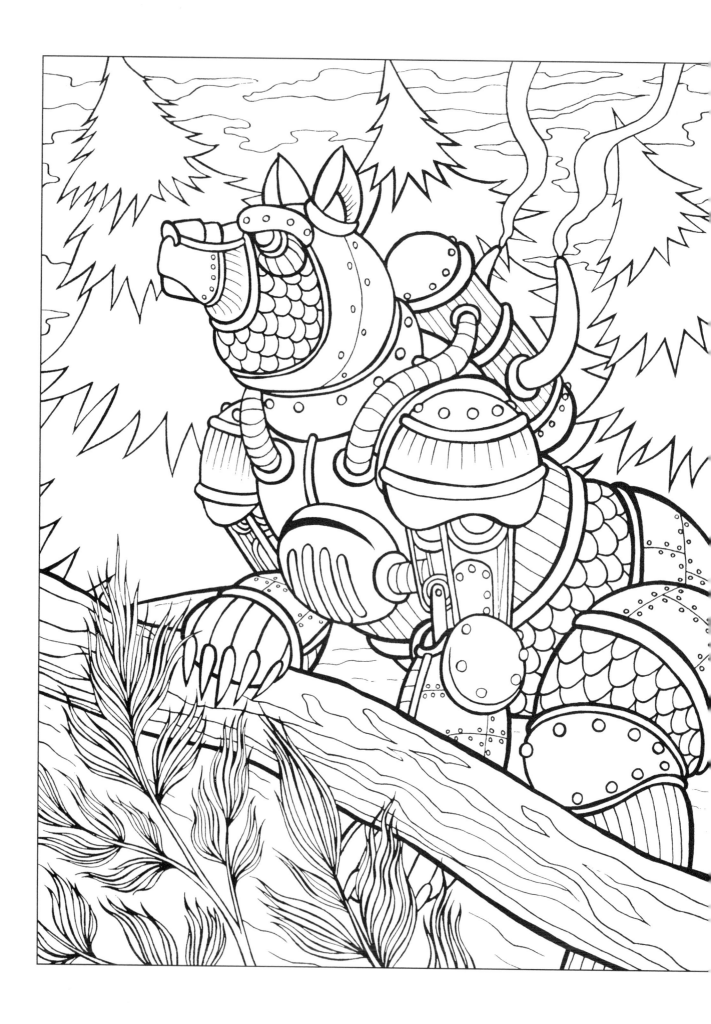

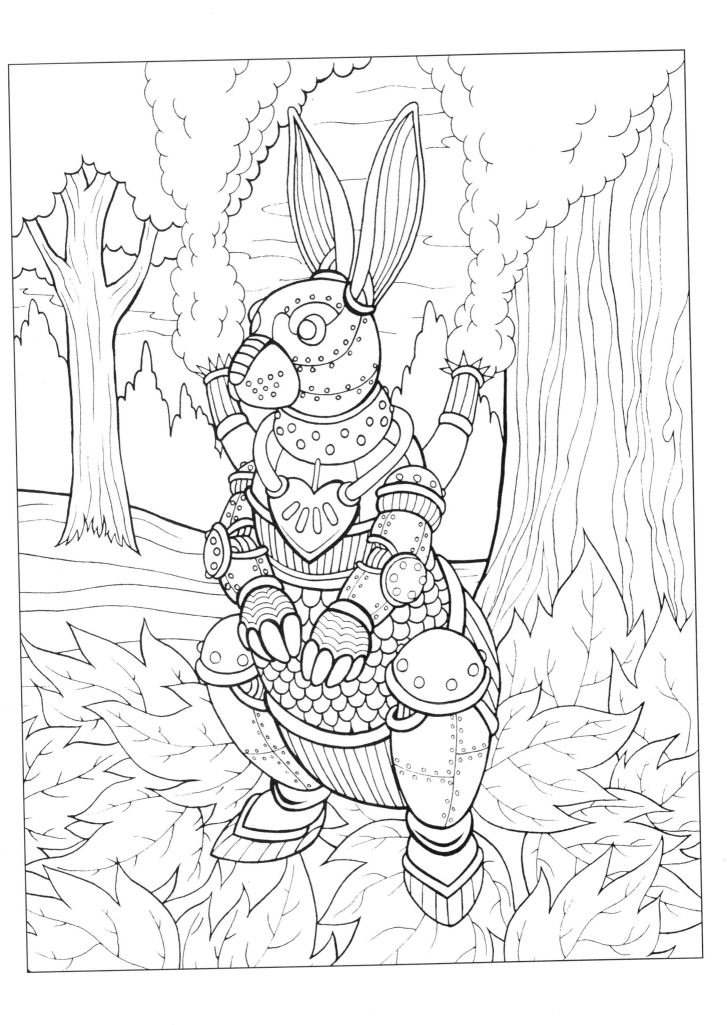

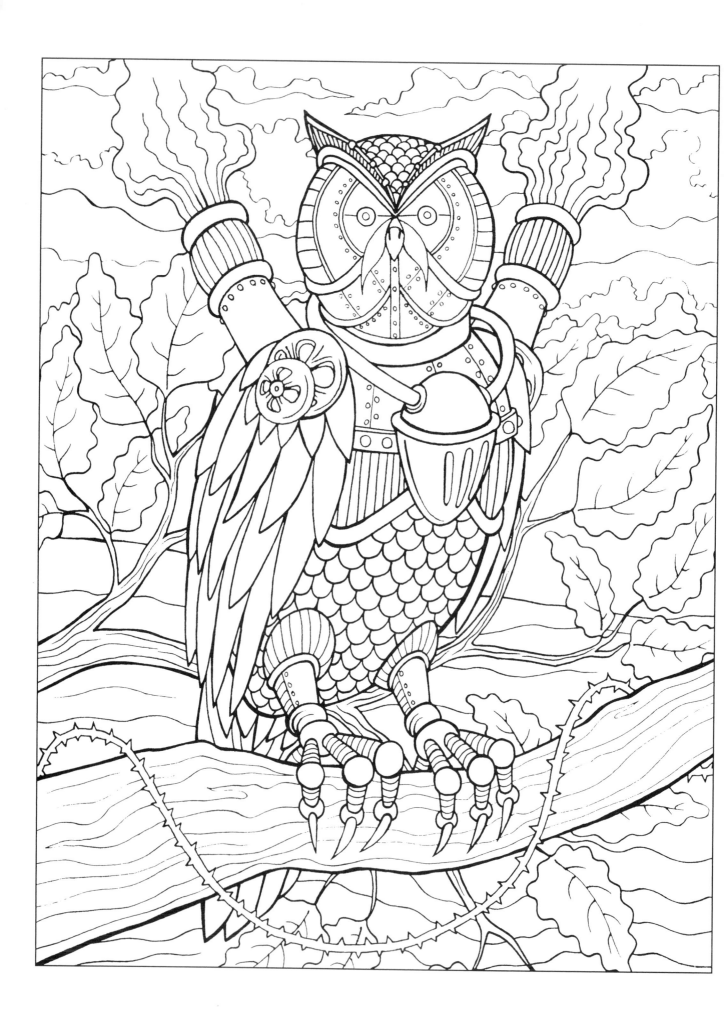

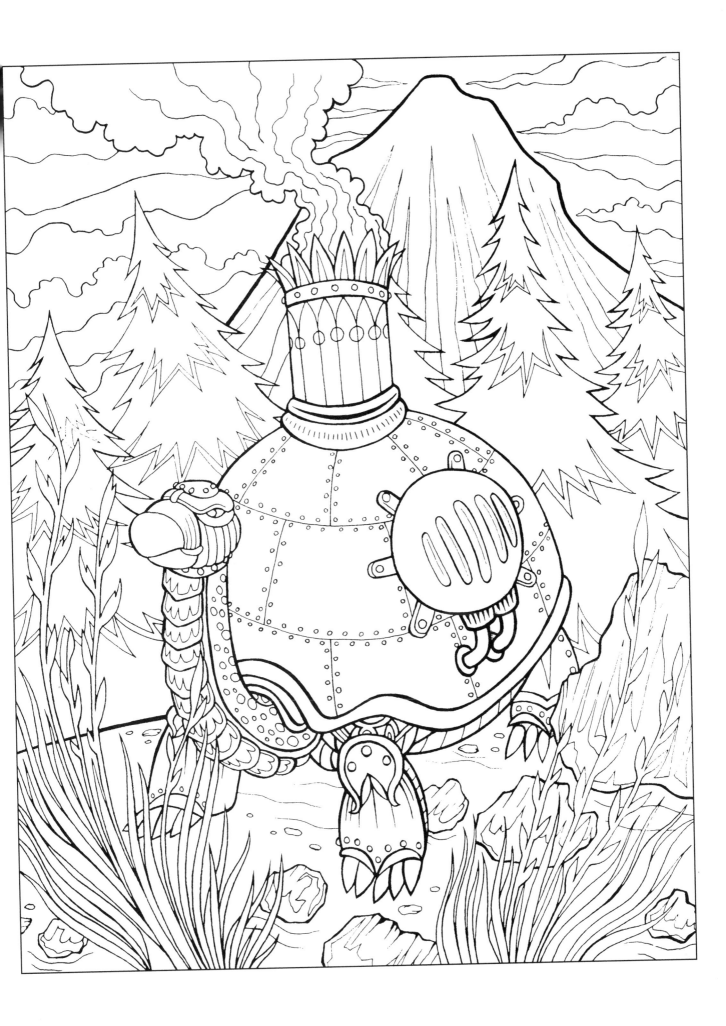

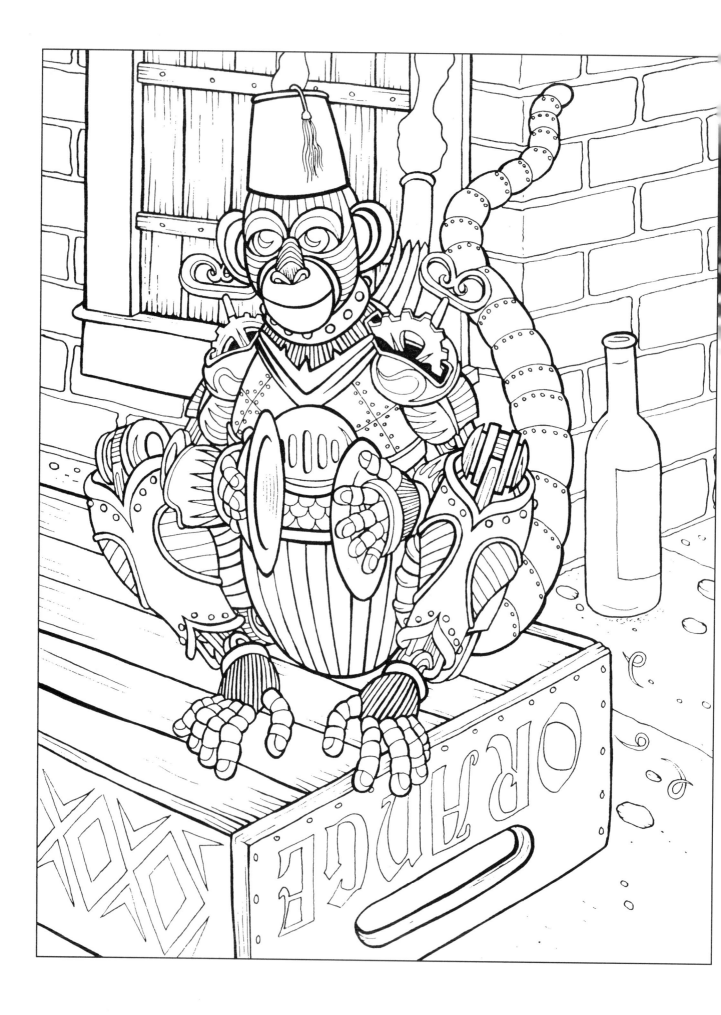

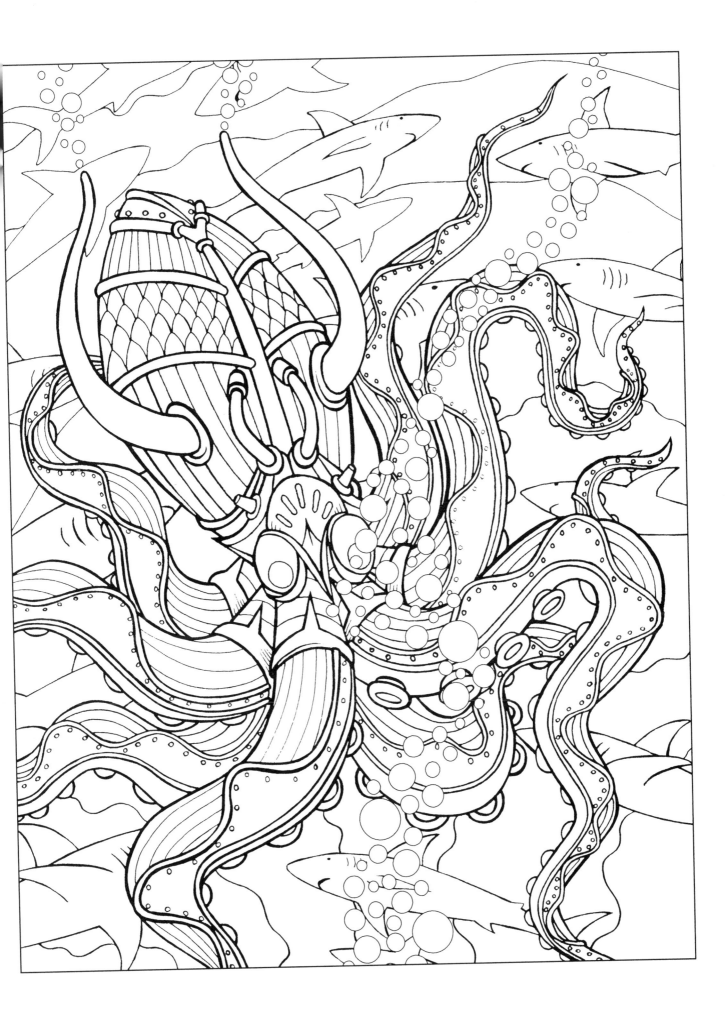

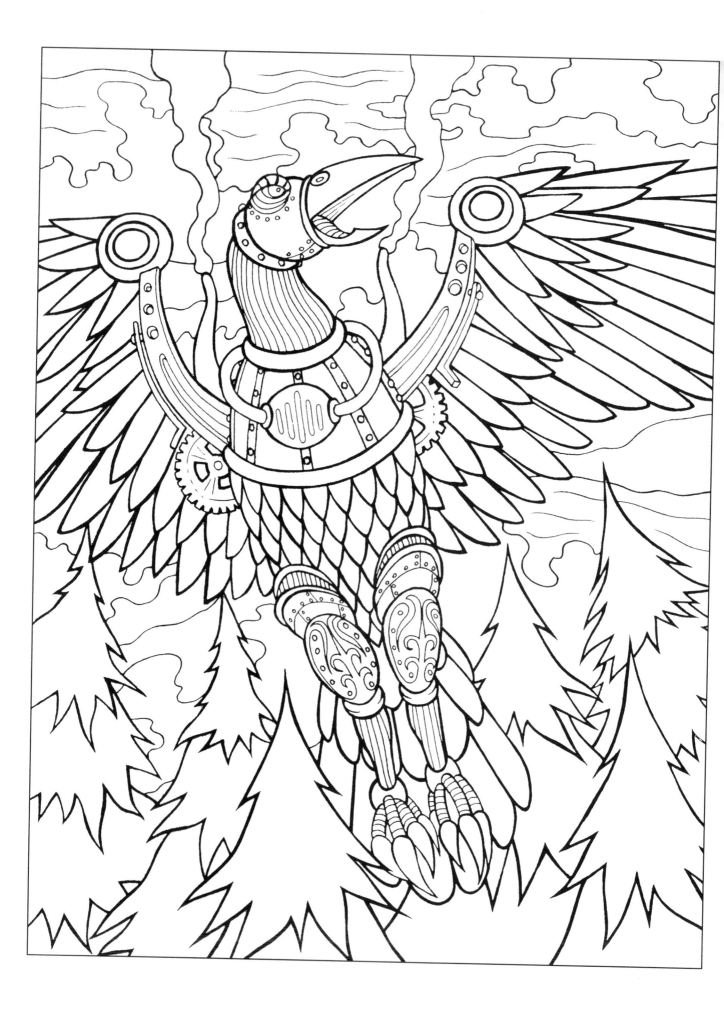

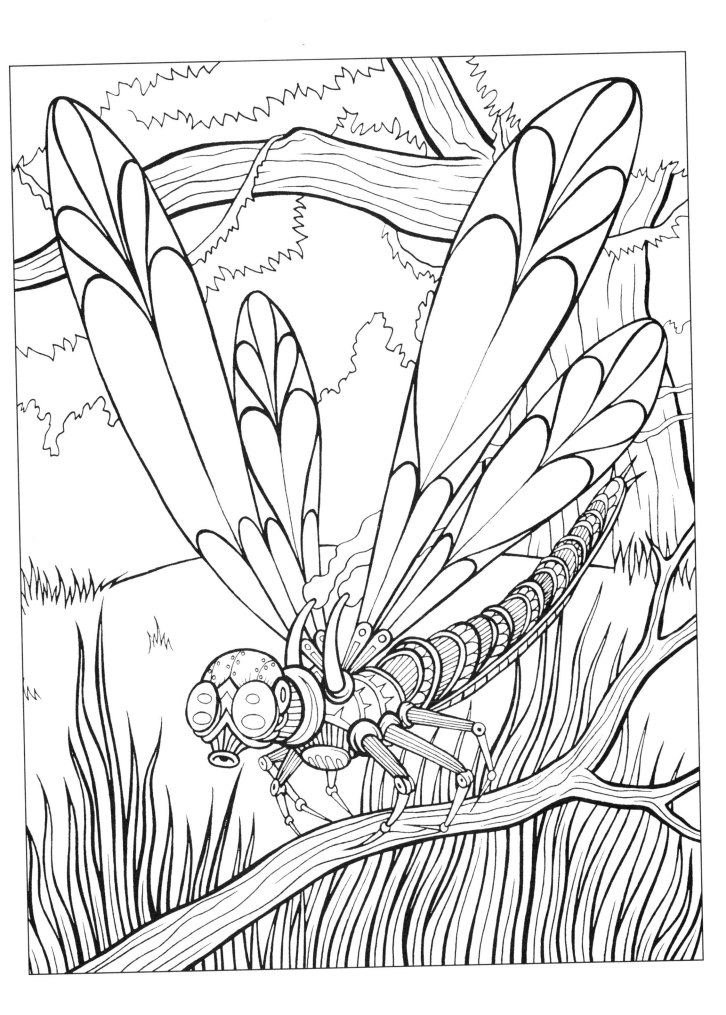

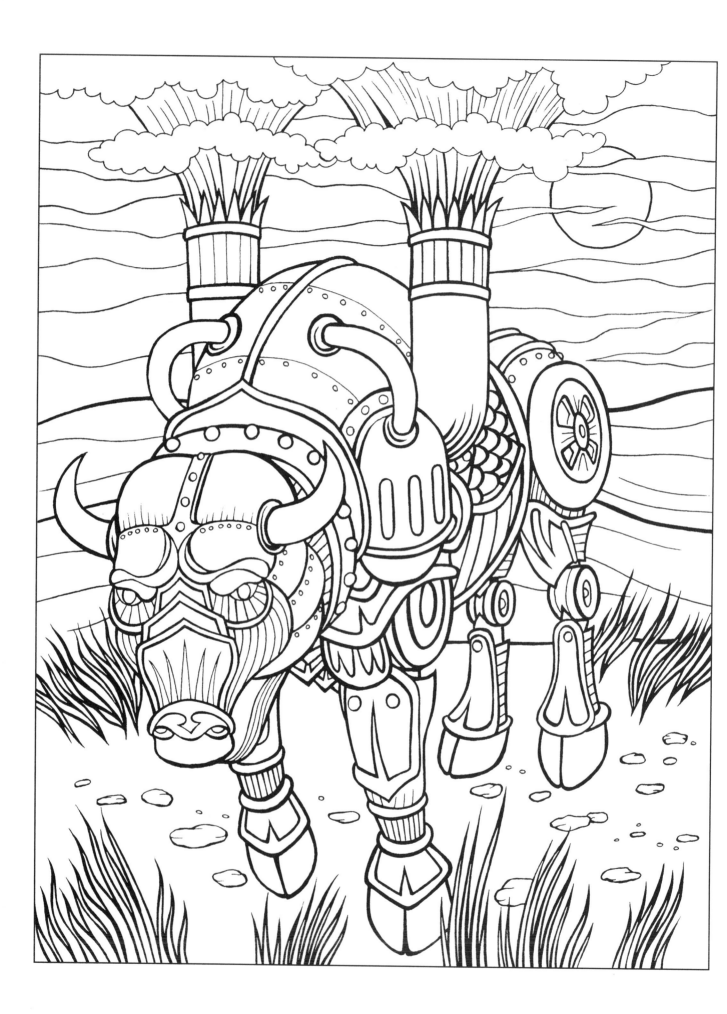

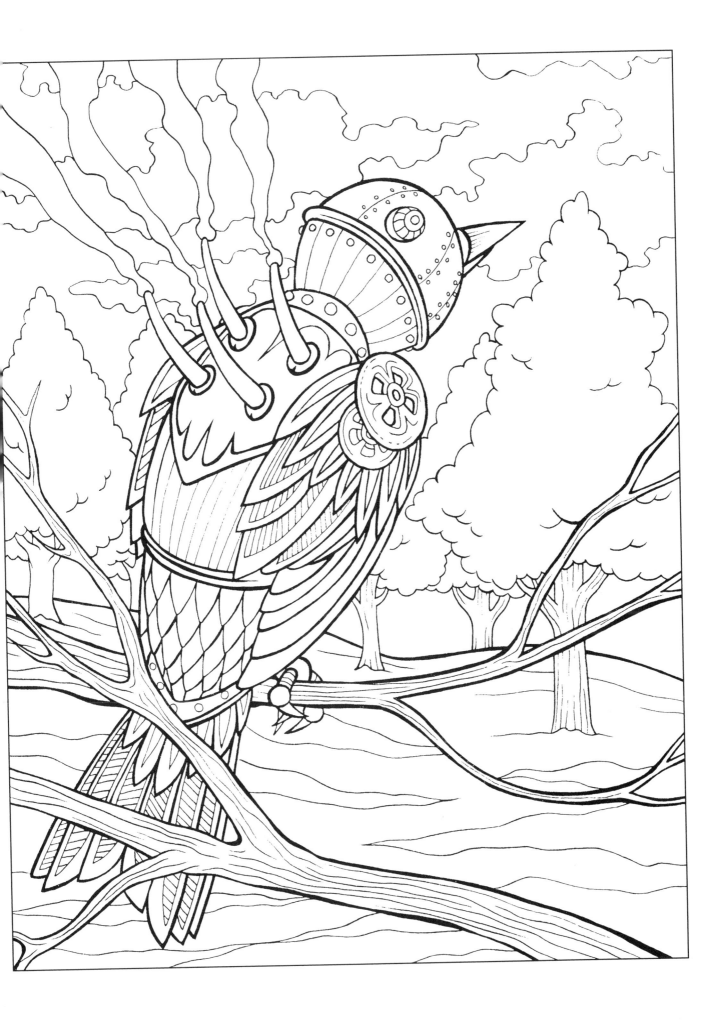

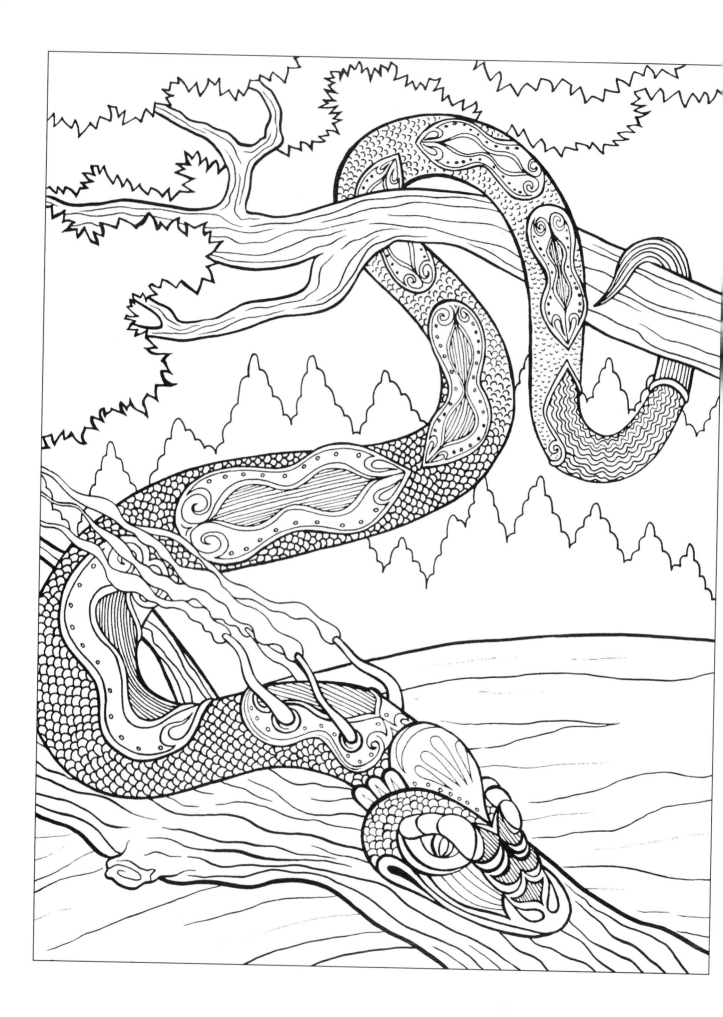

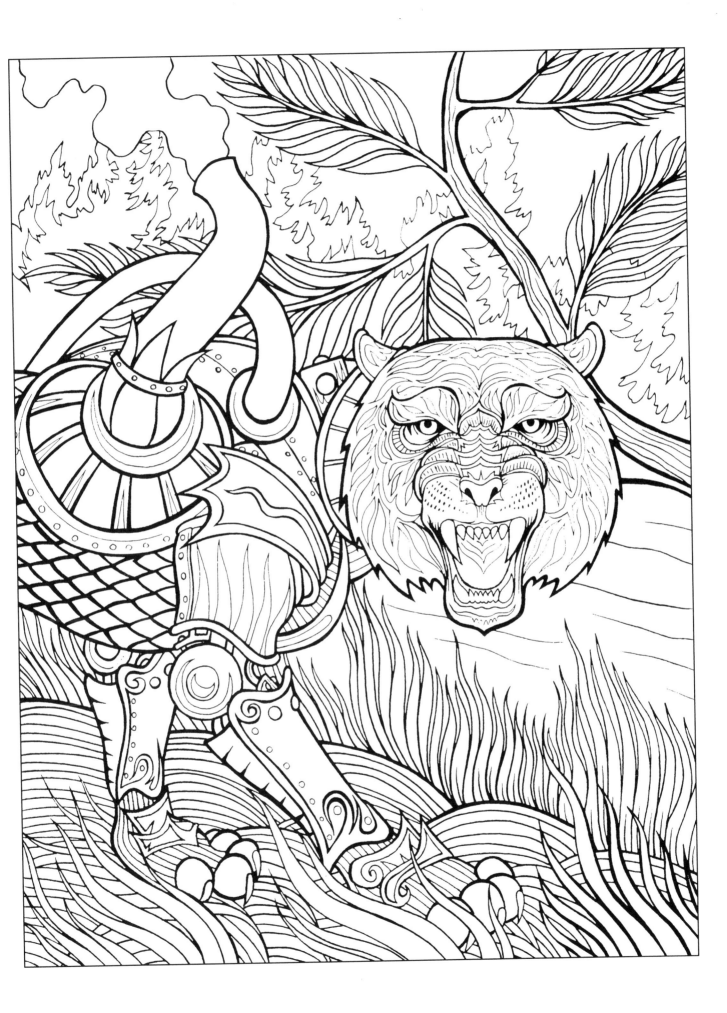

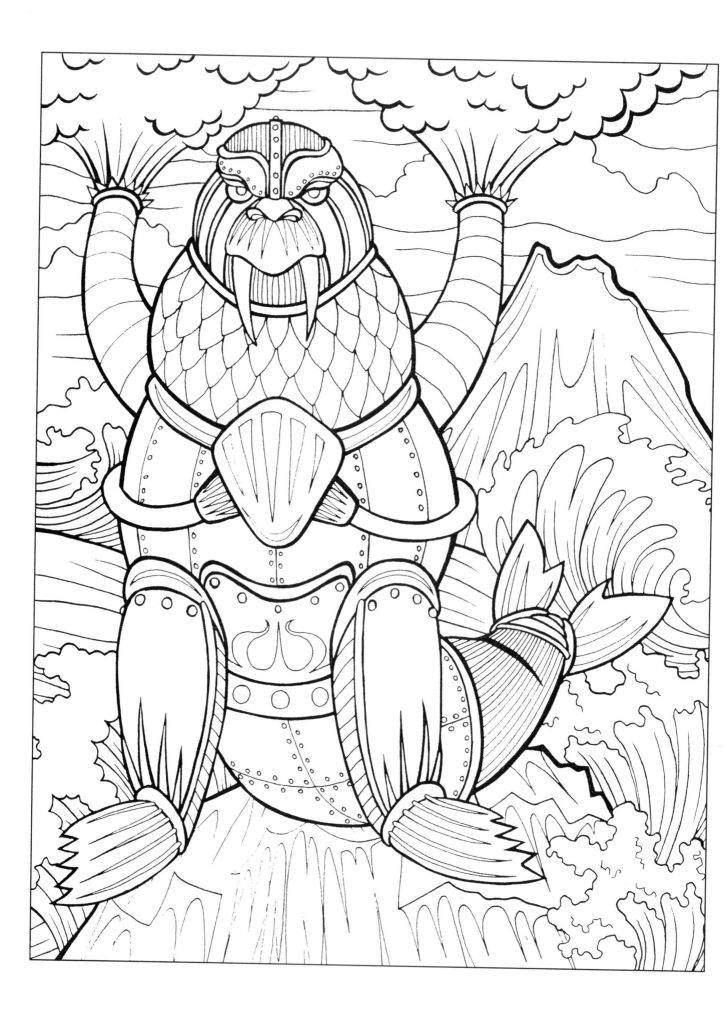

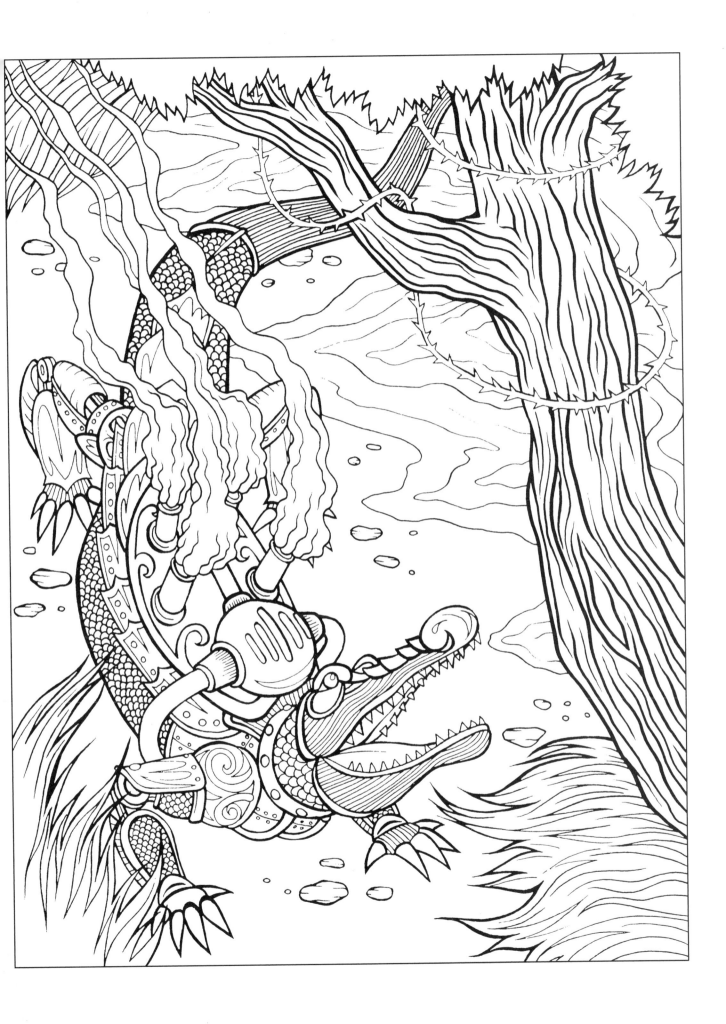

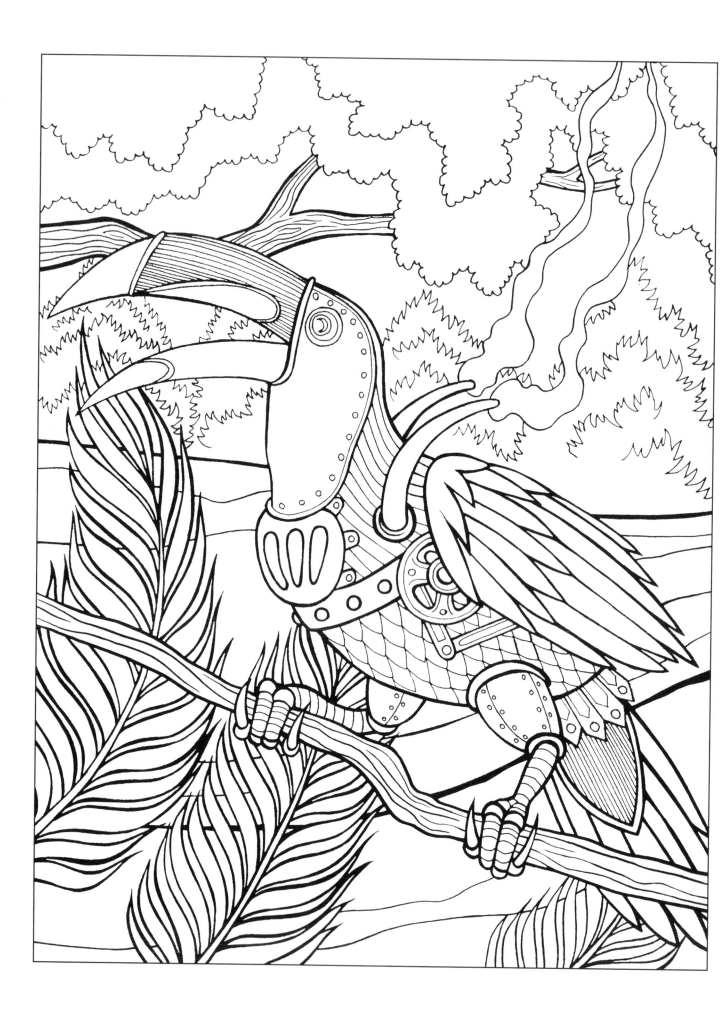

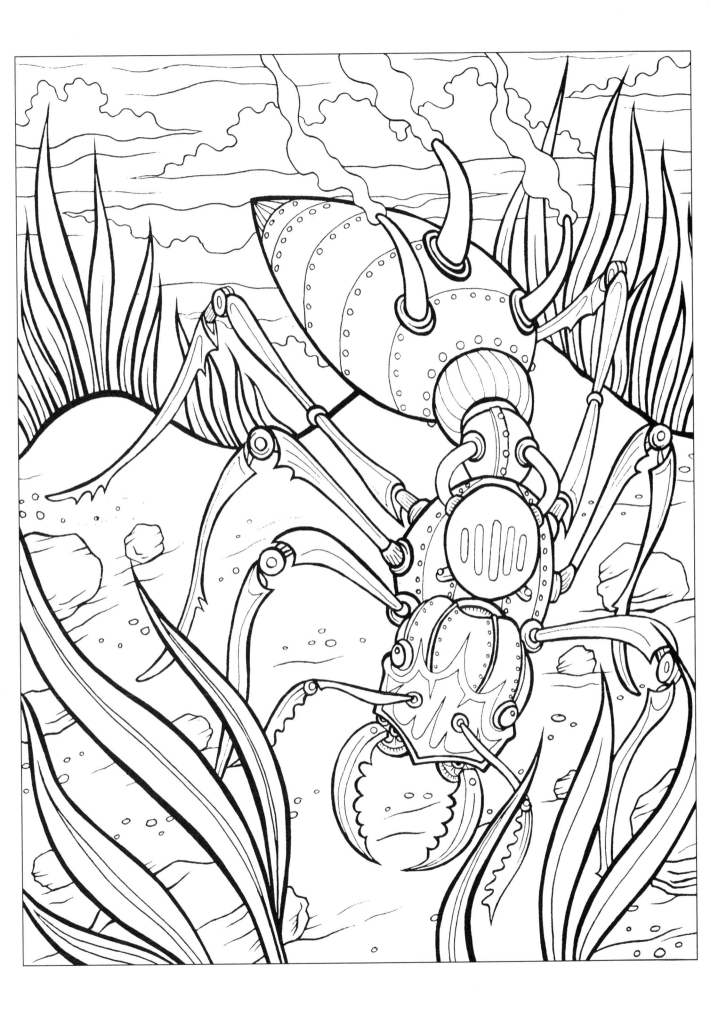

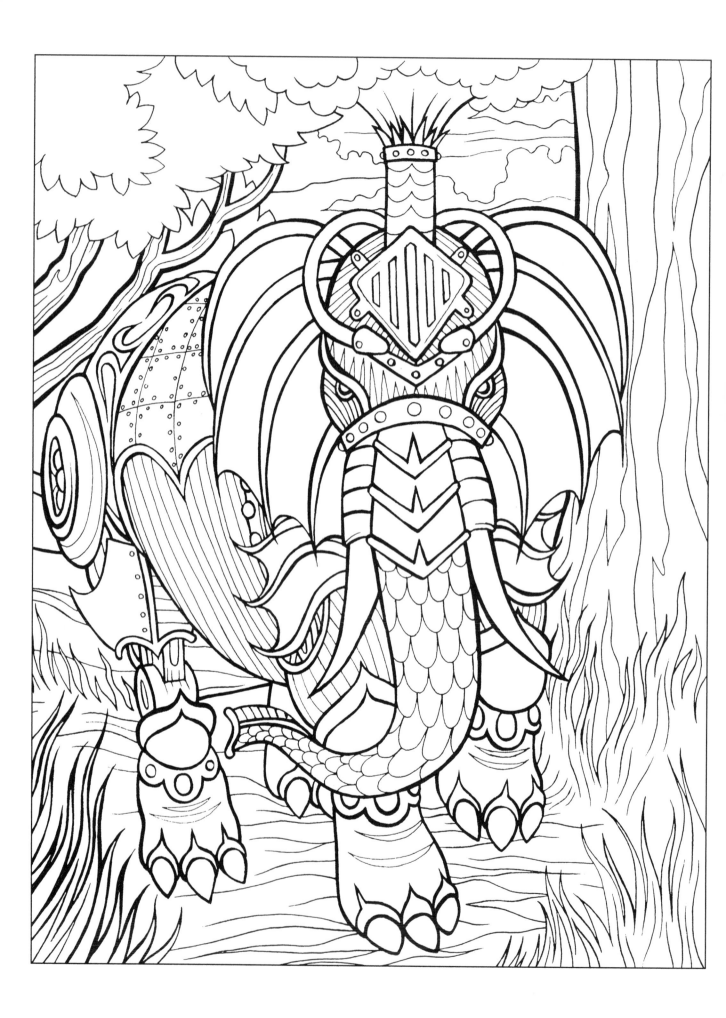

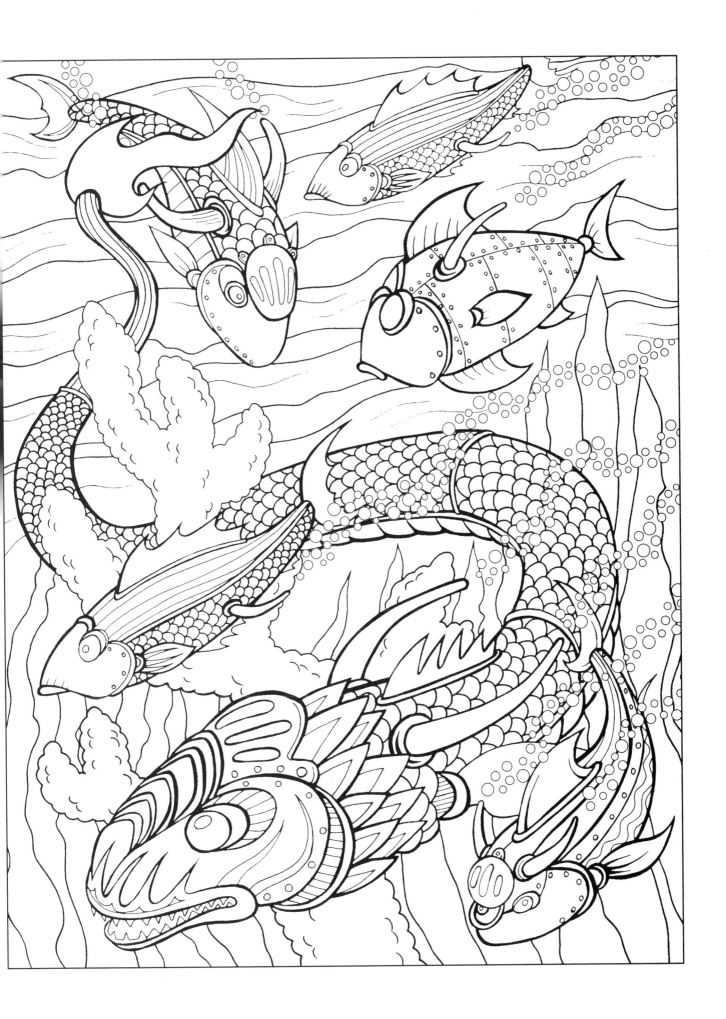

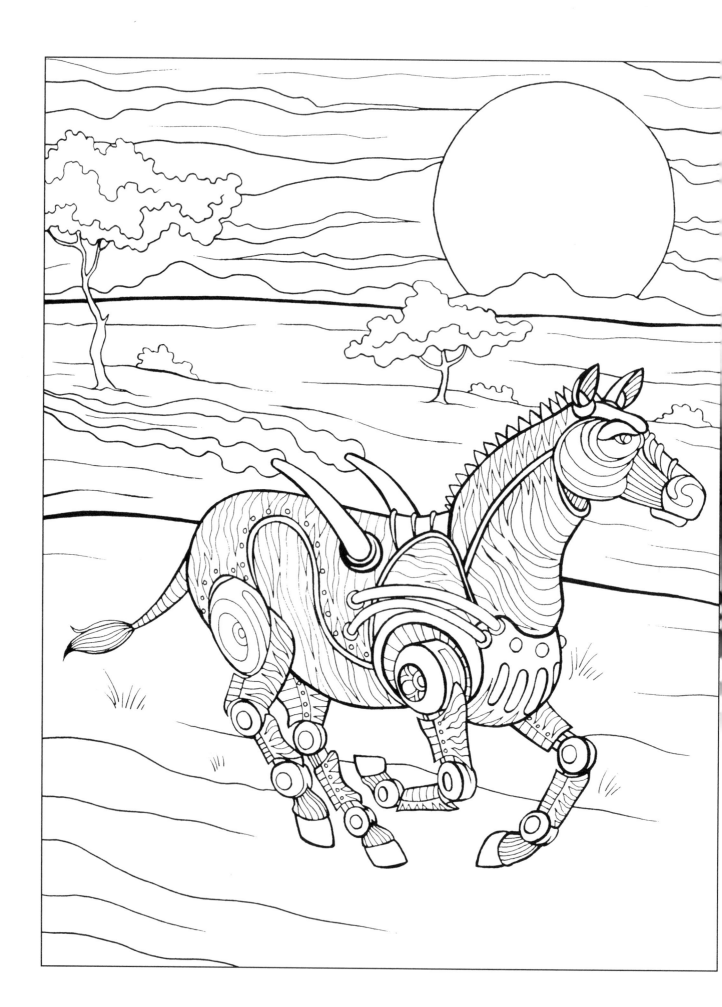

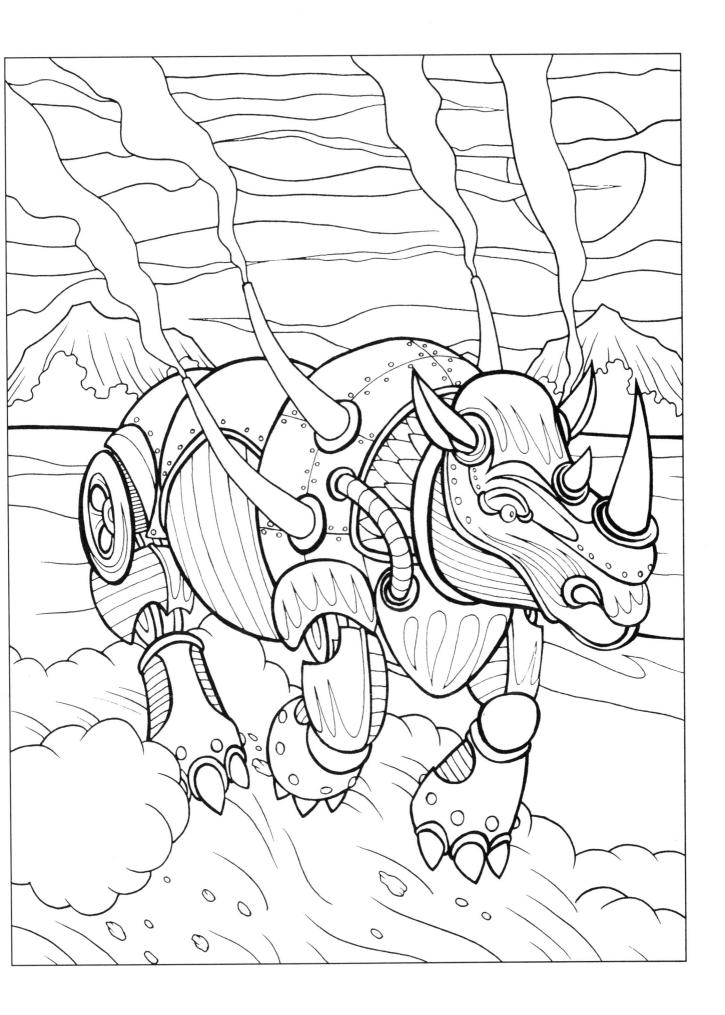

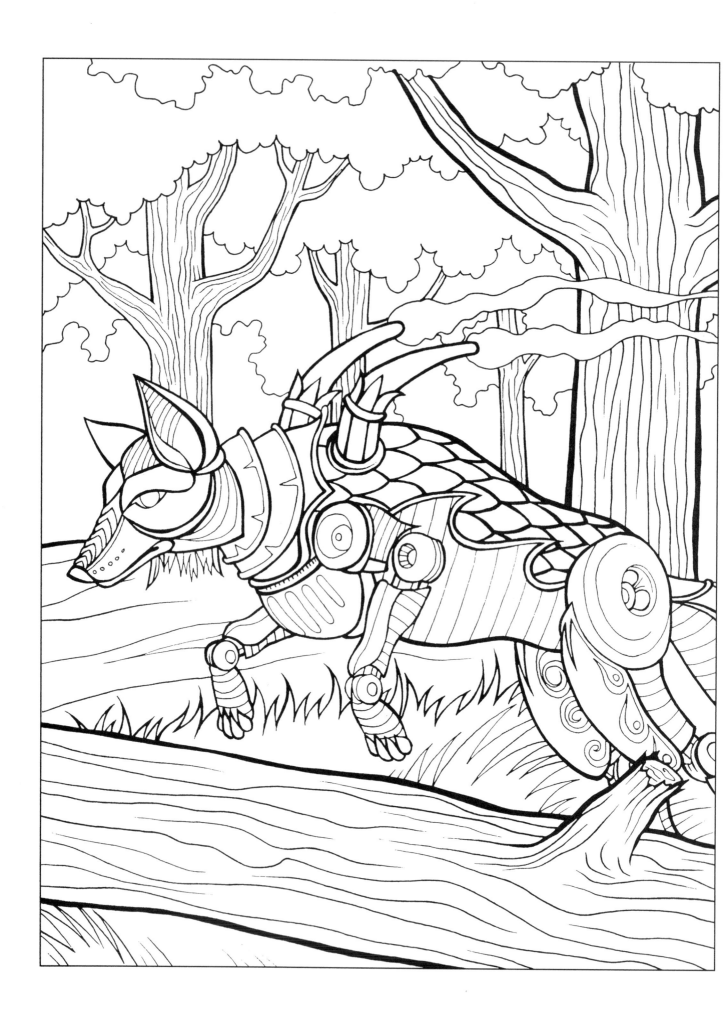

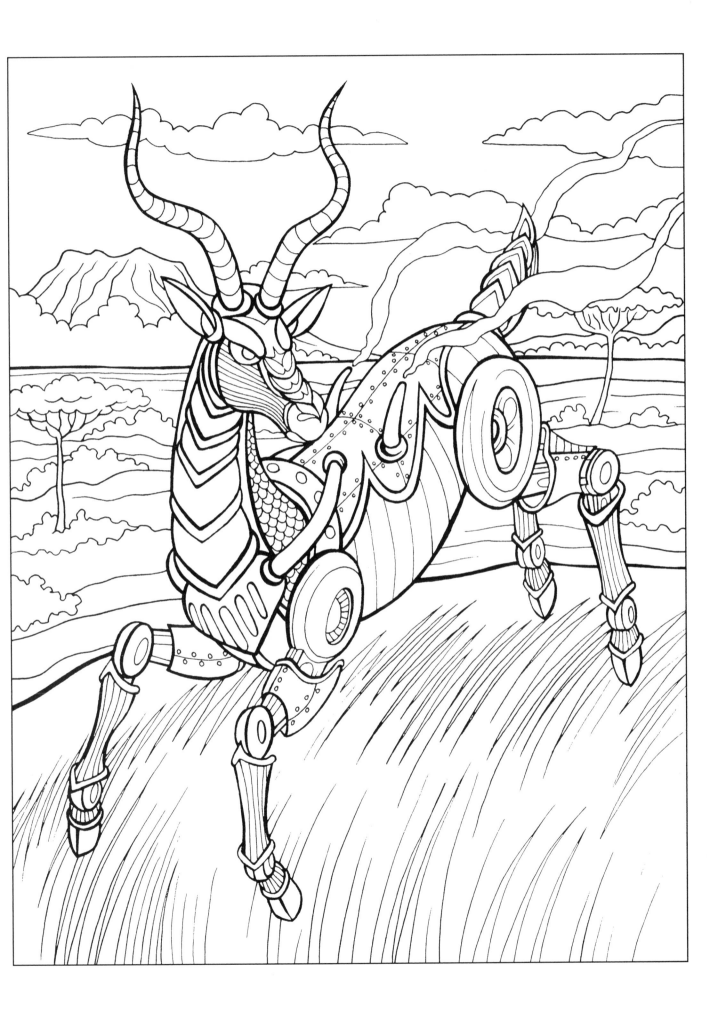

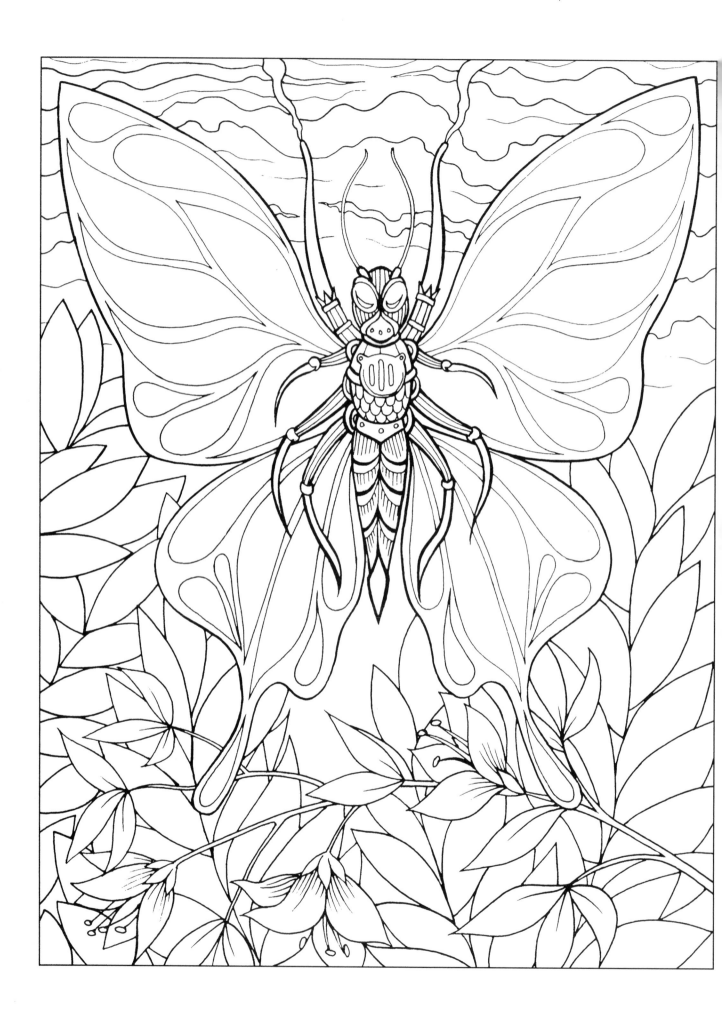

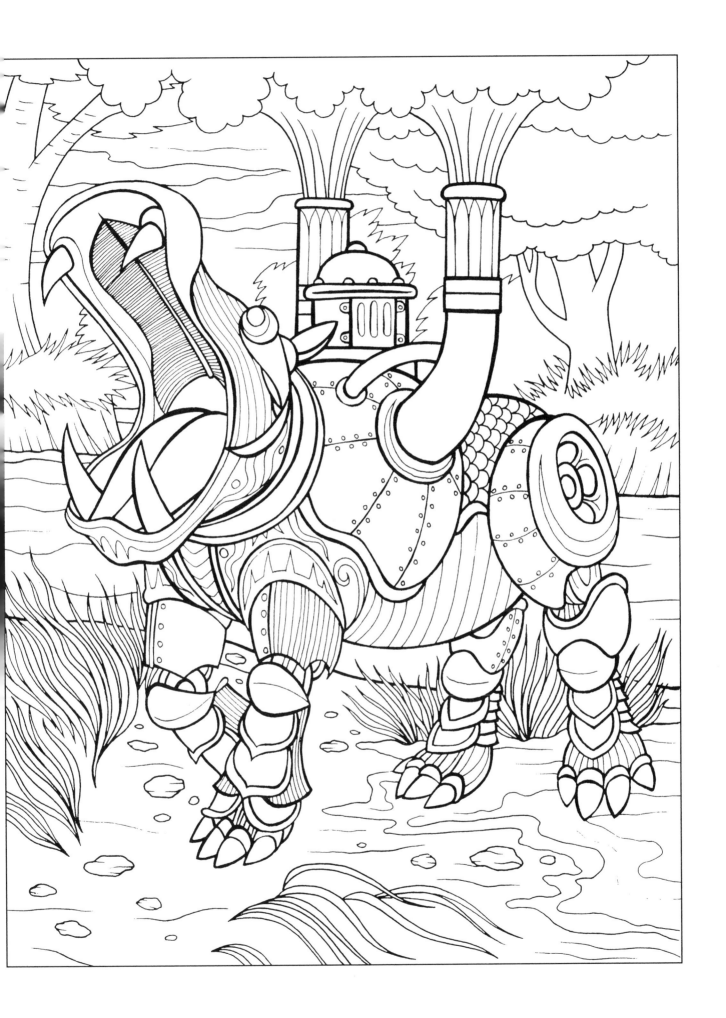

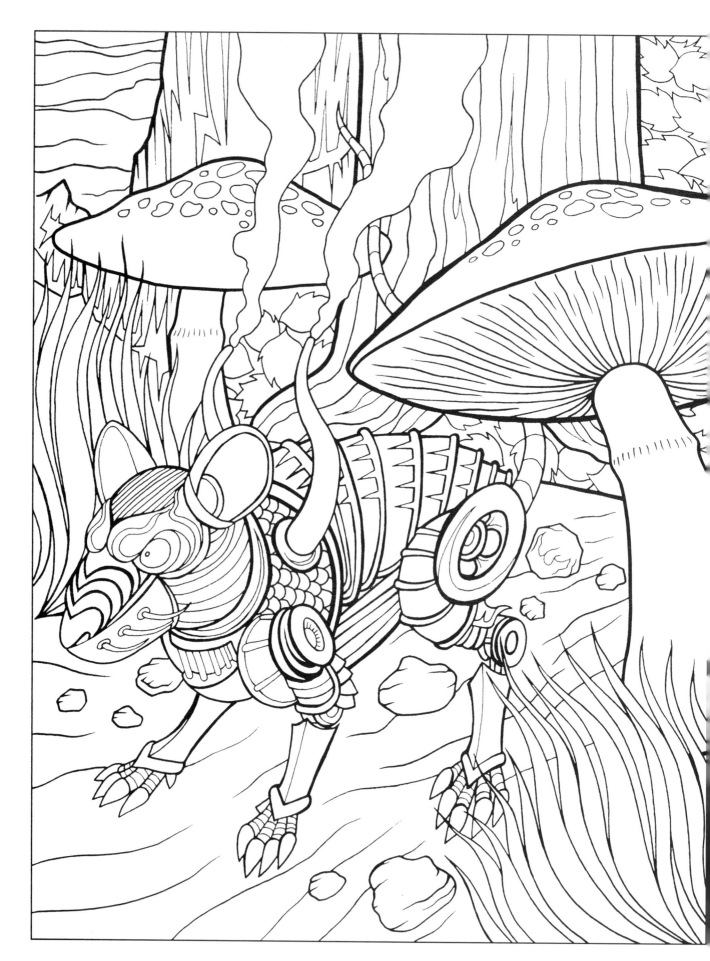

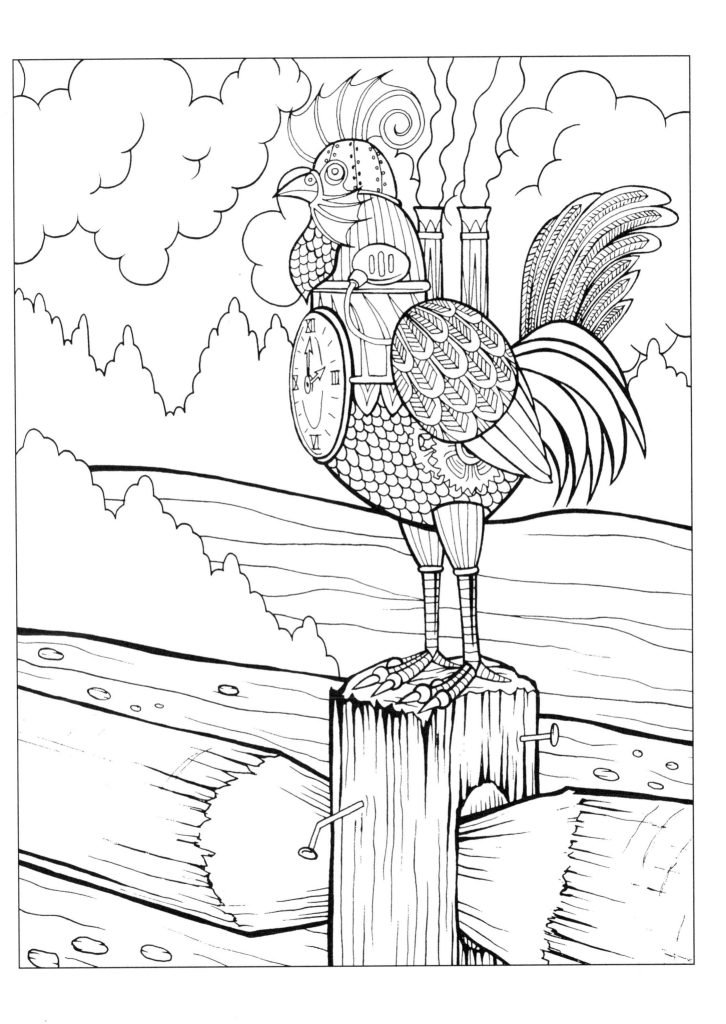

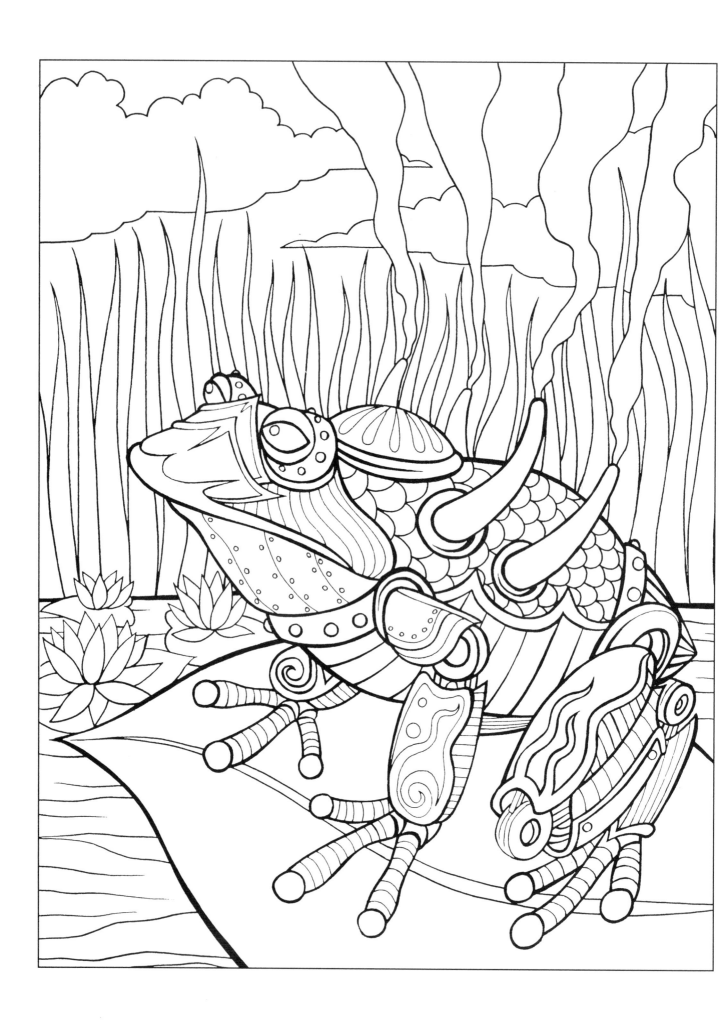

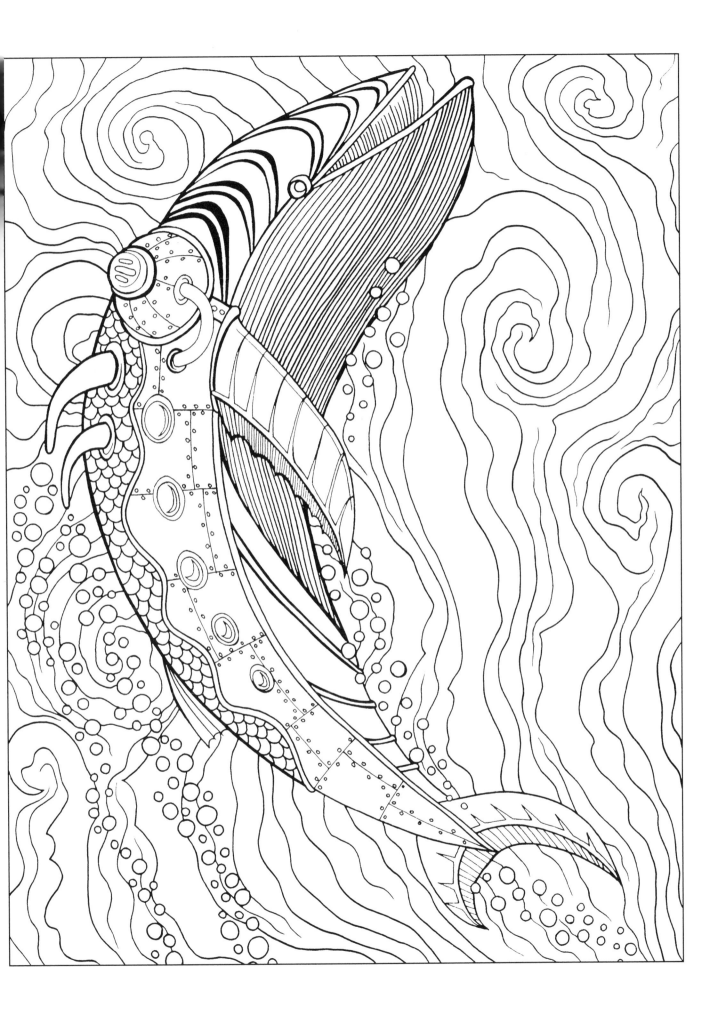

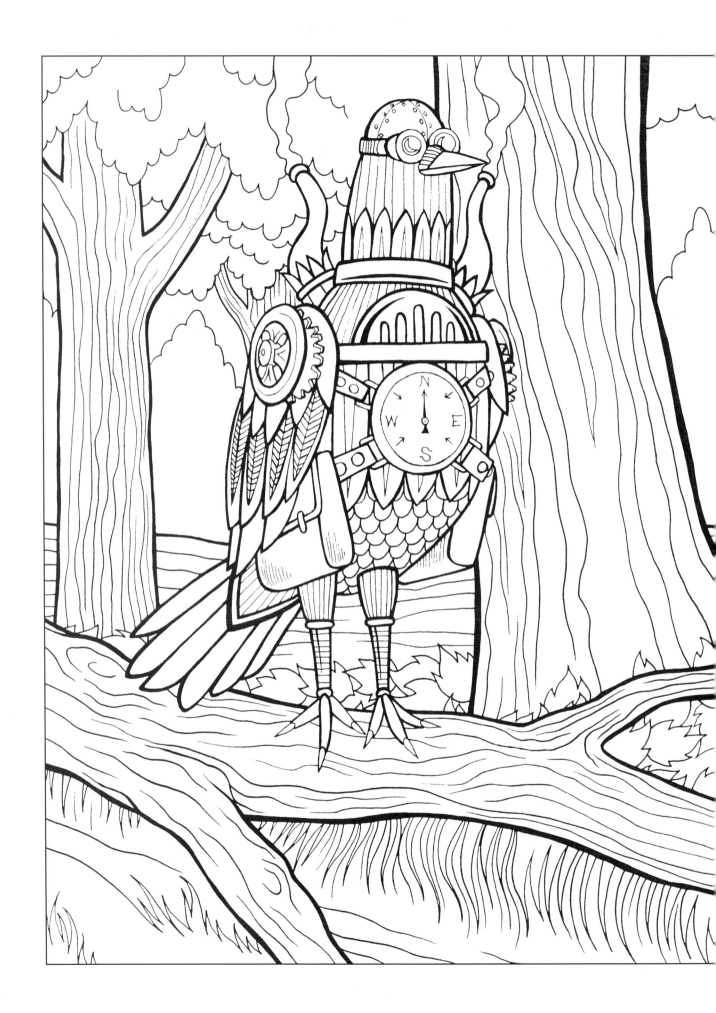